David Nash

WOOD PRIMER

The Sculpture of David Nash

BEDFORD PRESS

WOOD PRIMER

Library of Congress Catalog No: 87-14322

1. Nash, David, 1945– 2. Sculpture, British.
3. Sculpture, Modern — 20th century – Great
Britain. 4. Environment (Art) I. Title.
NB497.N37A4 1987 730'.92'4
87–14323

ISBN 0-938491-07-5 Casebound
ISBN 0-938491-08-3 Paperback

This volume is also published in a special
edition of 26 copies hand bound by Klaus-
Ullrich S. Rötzscher, each of which is signed
and lettered and contains an original drawing
by the author.

Wood Primer is the first in a series of Bedford
Press books conceived by artists.

Photos by David Nash, Sue Wells,
Howard Bowcott, and Keith Eastwell.

BEDFORD PRESS
472 Jackson Street
San Francisco
California 94111

First printing
Printed in Japan
Overseas Printing Corporation

damp and dry
burnt and buried
wood is given
we do not make it
in air it cracks
in fire it burns
in water floats
in earth returns

From the cycle of growth and decay
I borrow a part and prime it;
a simple idea applied to the qualities
and circumstances of each time and place.

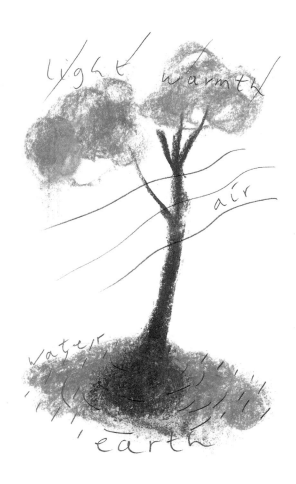

"The tree...is an upthrust of soil..."

—Rudolf Steiner

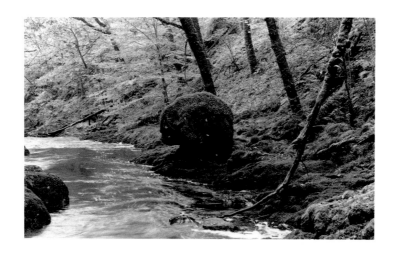

WOOD PRIMER

I

Bonk

Three Clams on a Rack, beech and oak, N. Wales 1974

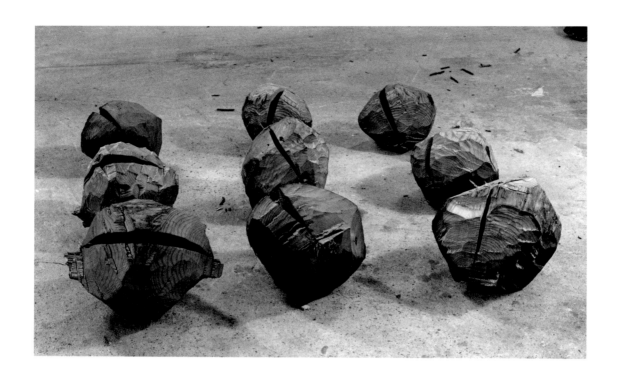

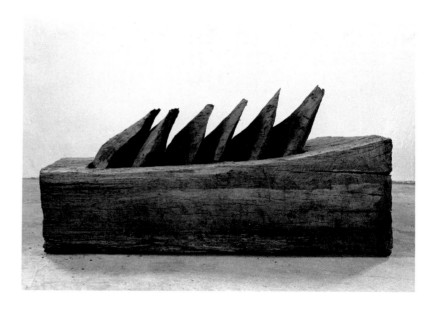

Nine Cracking Balls, ash, N. Wales 1970
Pods in a Trough, walnut and oak, N. Wales 1974

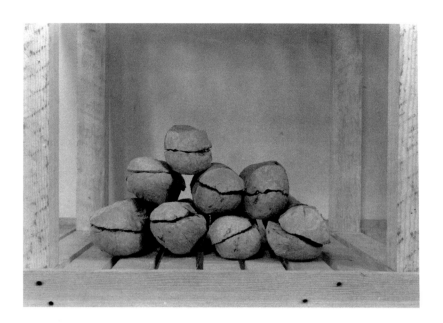

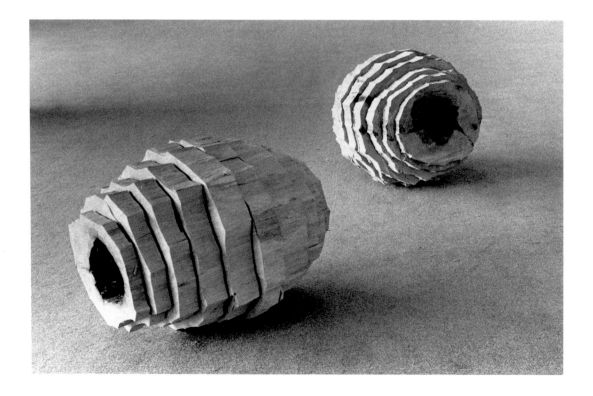

Pod Stack, beech, N. Wales 1975

Two Rough Balls, mizunara, Kotoku, Japan 1984

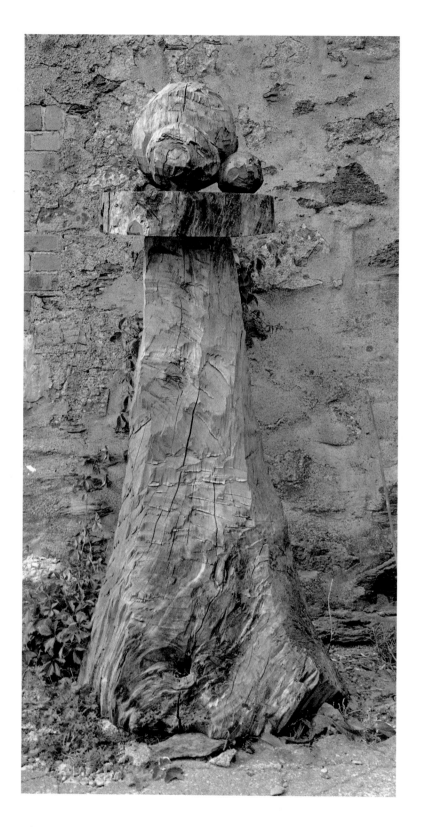

Three Bonks, sycamore, N. Wales 1971

13

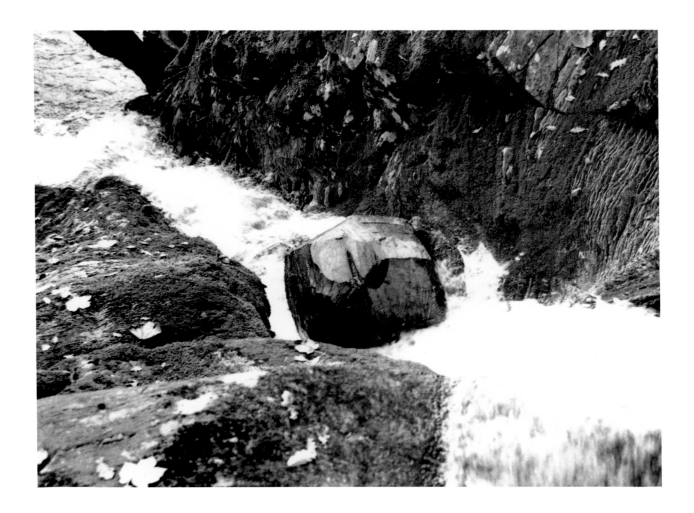

Wooden Boulder, oak, N. Wales 1978

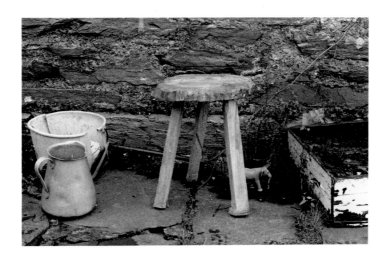

WOOD PRIMER

II

Tripod

15

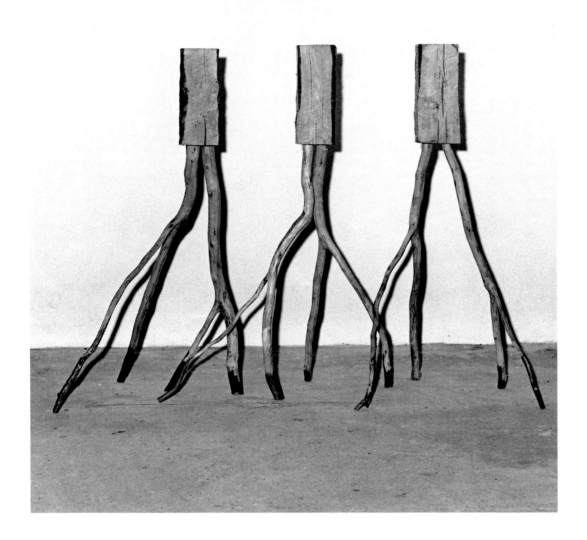

Three Dandy Scuttlers, oak and beech, N. Wales 1976

16

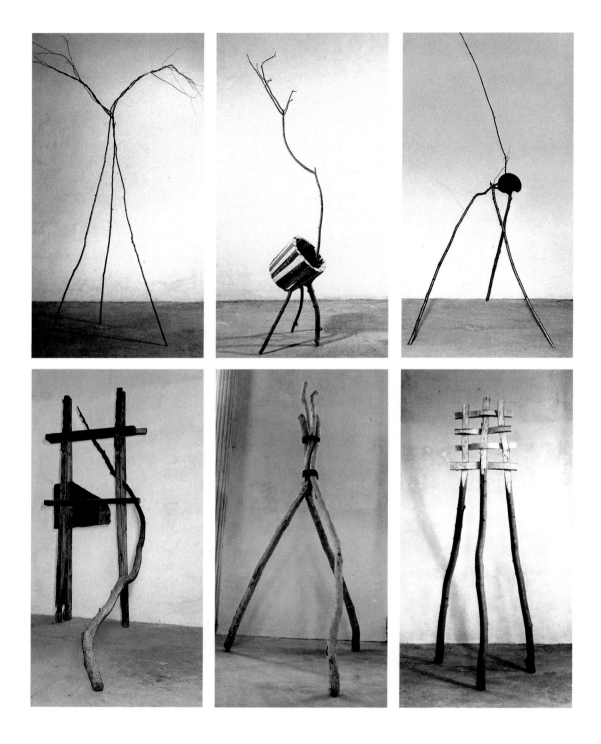

A Taint in the Wind, hazel, N. Wales 1977 *Branch Bucket,* ash, N. Wales 1983 *Over the Brow,* hazel and slate, N. Wales 1977
Elephant Passing a Window, oak and slate, N. Wales 1977 *Roped Birch Tripod,* N. Wales 1974 *Woven Ash Tripod,* N. Wales 1978

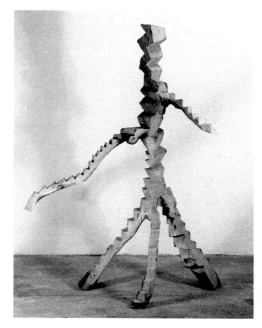

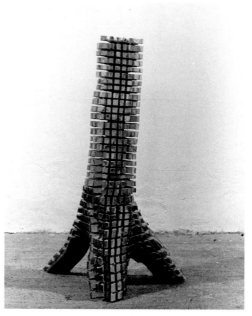

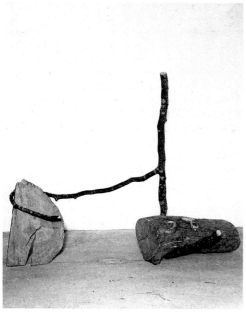

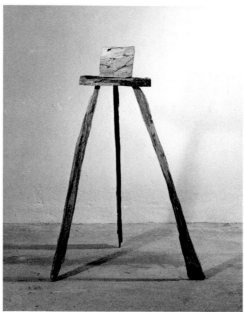

Stepped Oak Branch, Forest of Dean, England 1986 *Rough Tripod,* ash, N. Wales 1985
Off the Knee, oak and sycamore, N. Wales 1971 *Rough Block,* sycamore, N. Wales 1977

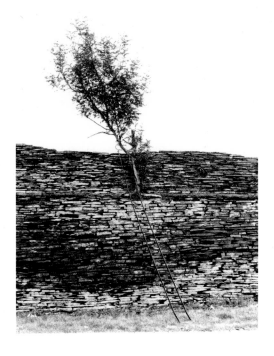

III

Ladder

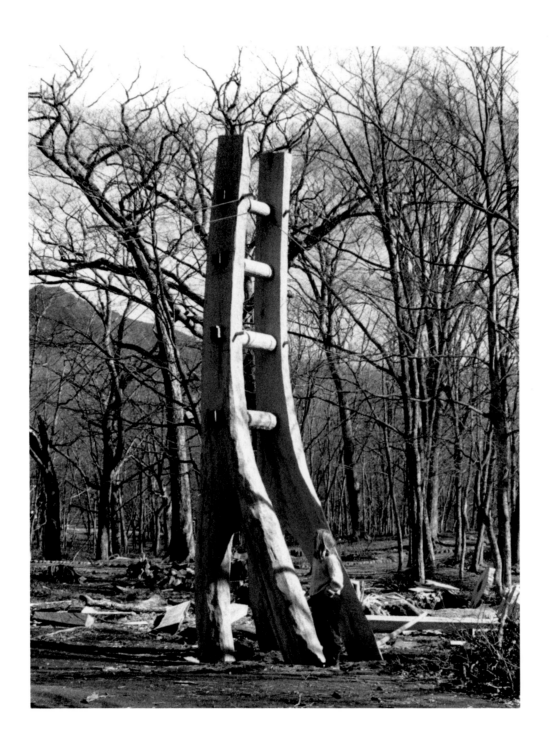

Big Ladder, mizunara, Kotoku, Japan 1984

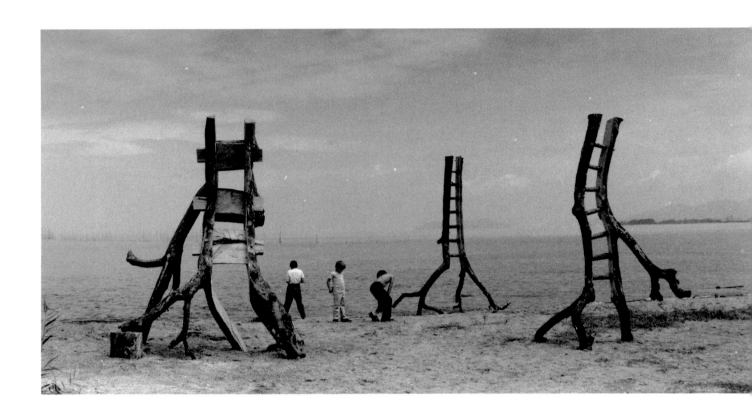

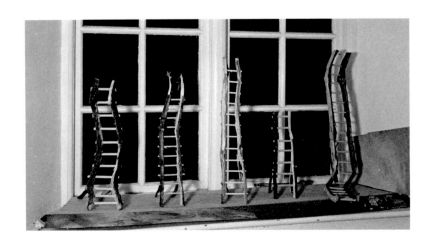

Ladders, mixed wood, Lake Biwa, Japan 1984
Ladders, oak, Cumbria, England 1978

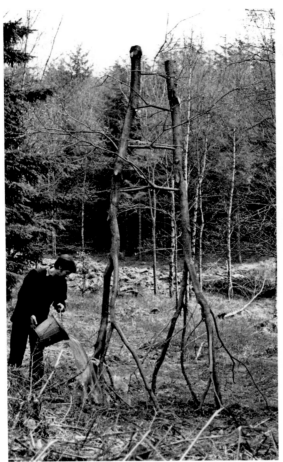

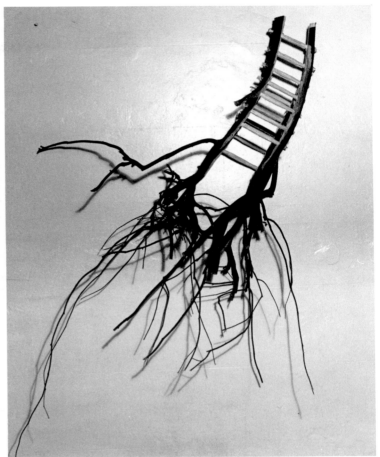

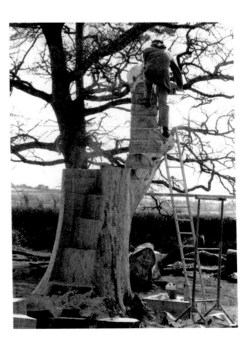

Willow Ladder, Cumbria, England 1978
Flying Ladder, lime, Berkshire, England 1983
Through the Trunk, up the Branch, elm, Tipperary, Ireland 1985

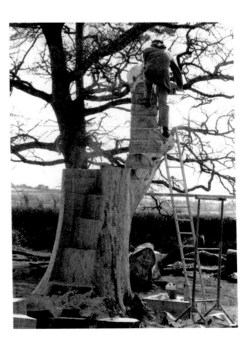

IV

Slice and Warp, Crack and Bend

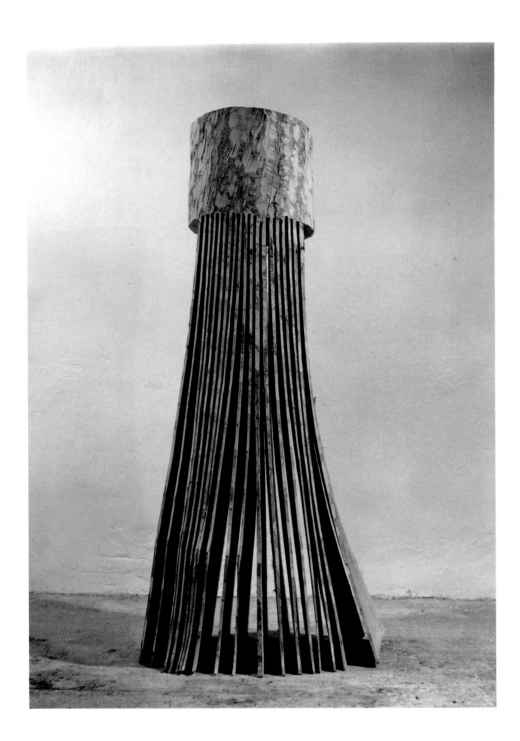

Skirted Beech, N. Wales 1985

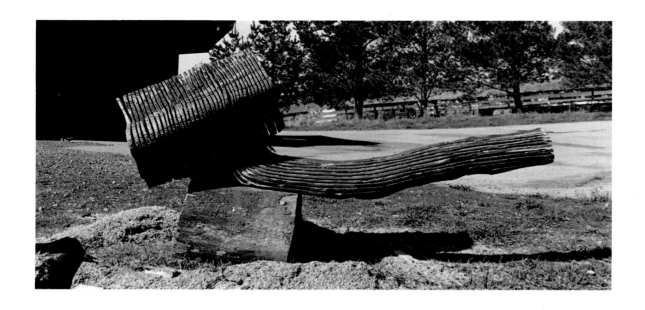

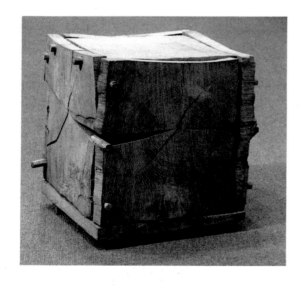

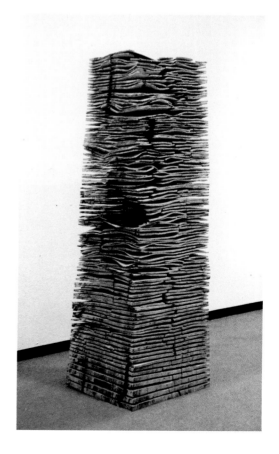

Layered Lump and Limb, madrone, California 1987
Cracking Box, oak, N. Wales 1979
Crack and Warp Column, beech, N. Wales 1986

25

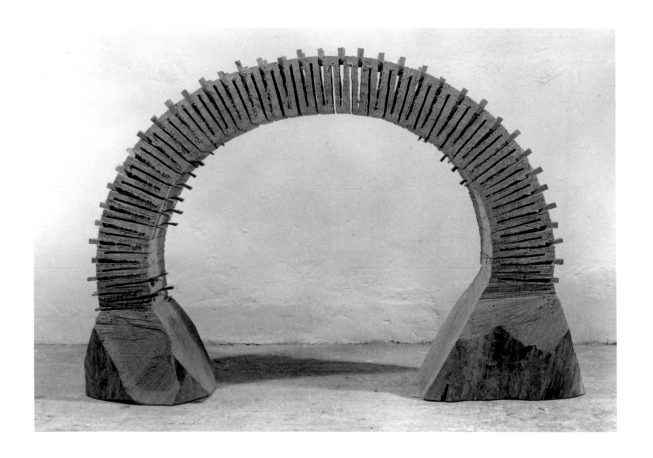

Elm Spring Arch, Kotoku, Japan 1984
Ash Ring Table, N. Wales 1985

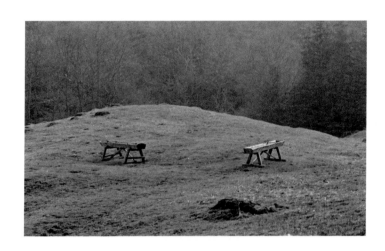

V

Table

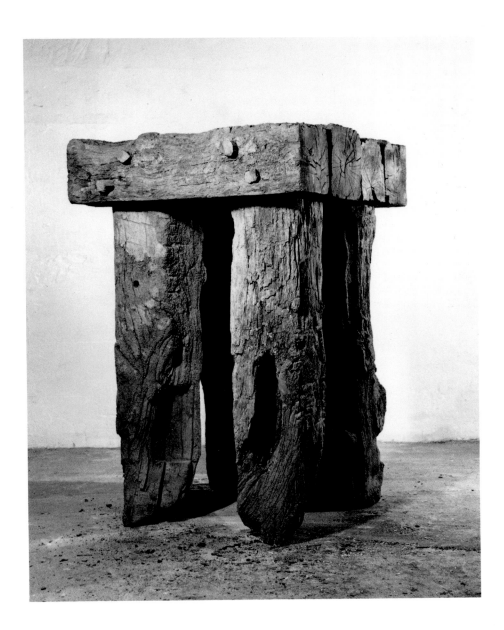

Ancient Table, oak, N. Wales 1983-4

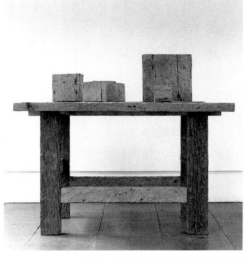 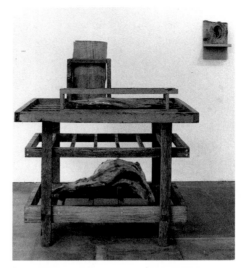

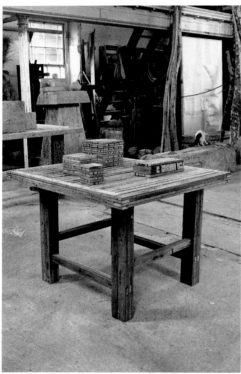 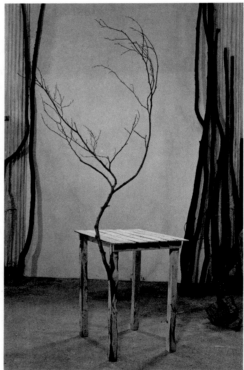

Table with Cubes, pine, N. Wales 1971 *In the Table,* oak, yew and beech, N. Wales 1974
Slat Table, pine, N, Wales 1975 *Branch Table,* beech, N. Wales 1977

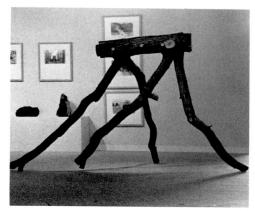

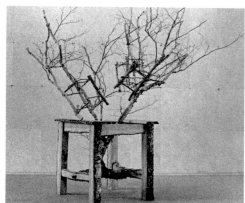

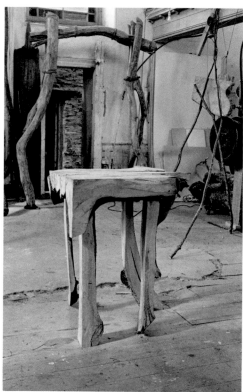

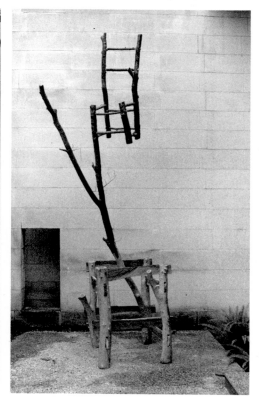

Running Table, oak, N. Wales, 1980 *Table and Chairs,* birch, Kotoku, Japan 1984

Corner Table, apple, N. Wales 1977 *Table and Chair,* elm, Australia 1985

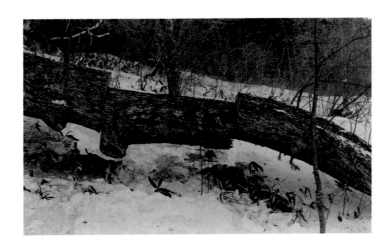

VI

Mantle-dis-mantle

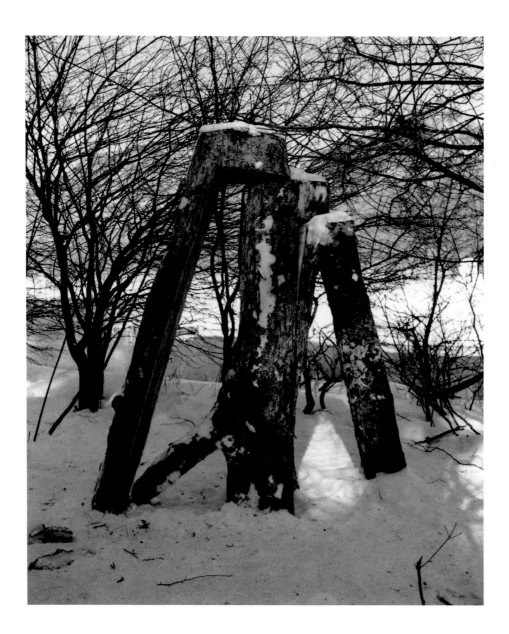

Capped arch, mizunara, Kotoku, Japan 1982

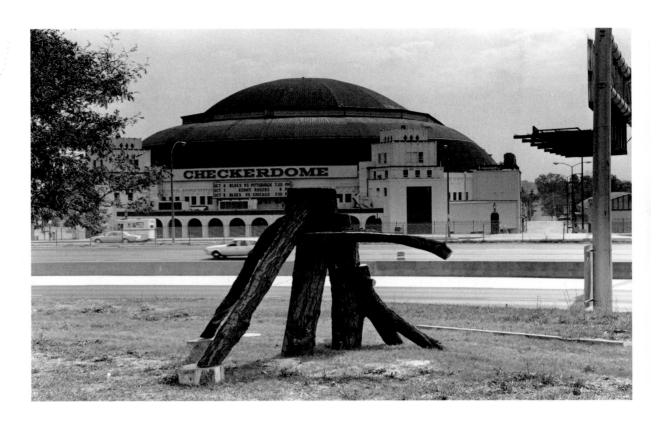

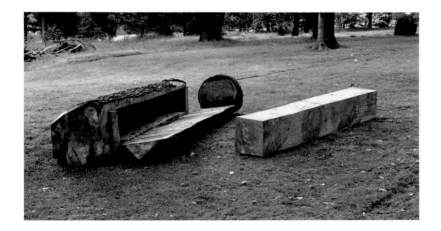

Mantle-dis-mantle, red oak, St. Louis, Missouri 1983
Space for a Length, elm, Yorkshire, England 1982

33

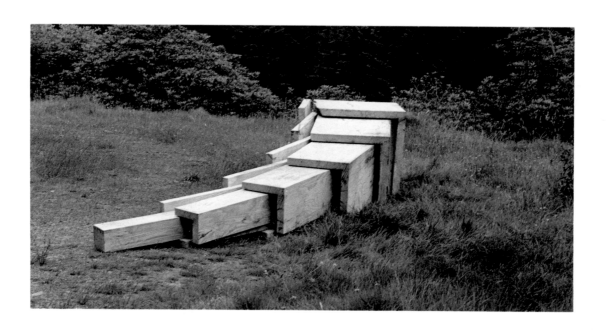

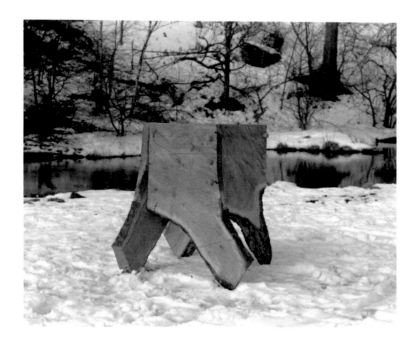

Extended Cube, beech, N. Wales 1986
Turning Box, mizunara, Kotoku, Japan 1982

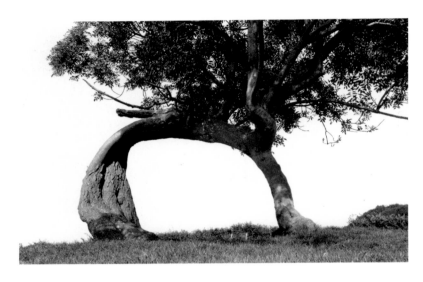

VII

Planting-Growing

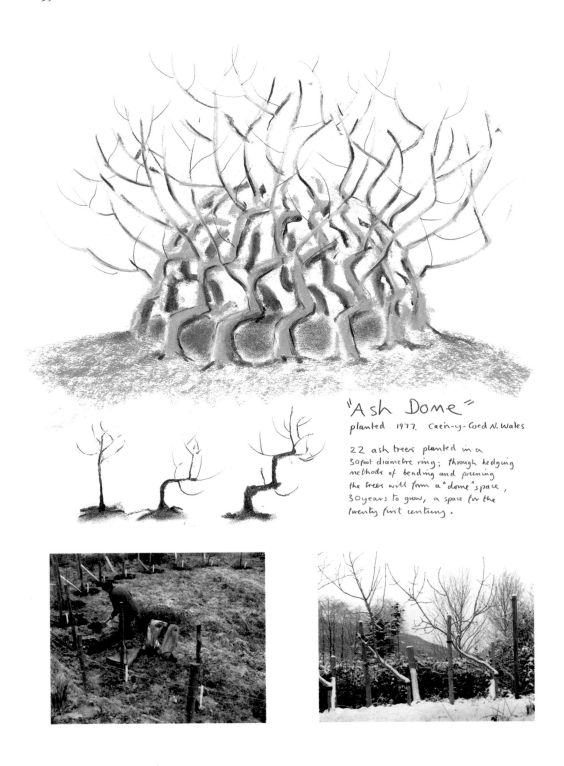

"Ash Dome"

planted 1977. Caein-y-Coed N. Wales

22 ash trees planted in a
30 foot diametre ring; through hedging
methods of bending and pruning
the trees will form a "dome" space,
30 years to grow, a space for the
twenty first century.

Mulching Ash Dome, Cae'n-y-Coed, N. Wales 1979 *First Bend, Ash Dome*, Cae'ny-Coed, N. Wales 1983

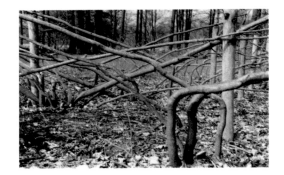

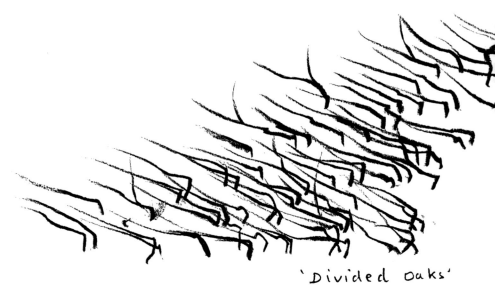

'Divided Oaks'

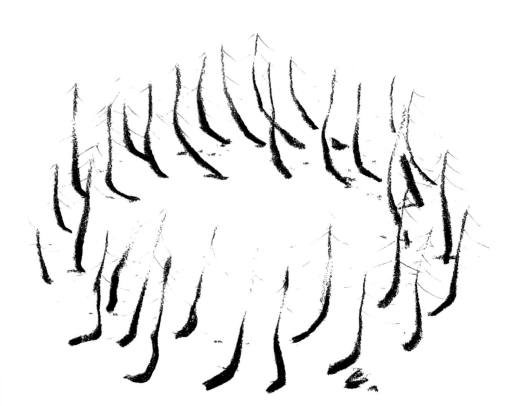

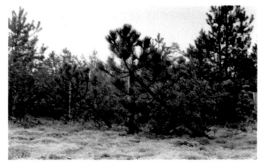

'Turning Pines'. Hoge Veluwe
Holland. started 1985

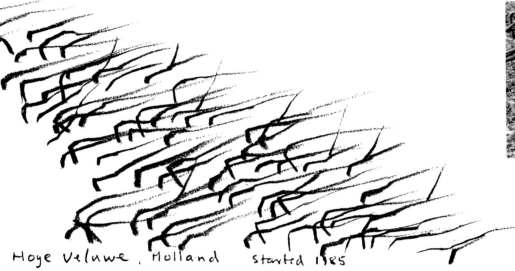

Hoge Veluwe, Holland Started 1985

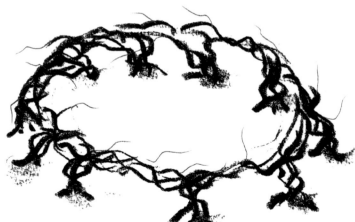

'Bramble Ring'
Caen-y-Coed - N. Wales
Started 1983

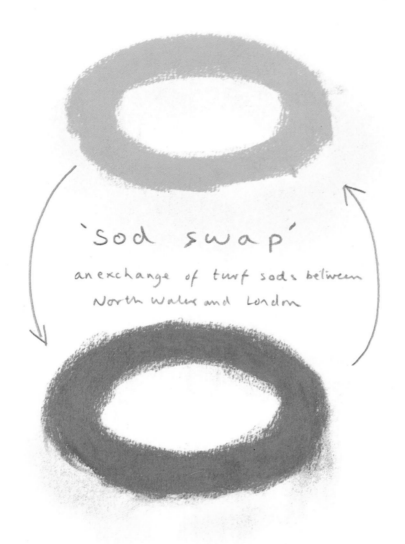

'sod swap'

an exchange of turf sods between
North Wales and London

a ring of sods from Cae'n-y-Coed exchanged for a ring from Kensington.
- 1983 -

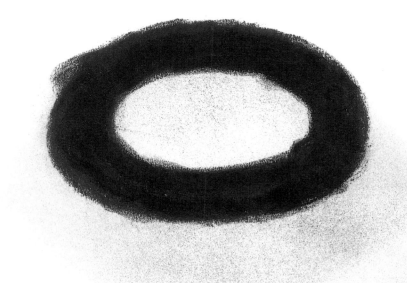

'Blue Ring'

— Cae'n-y-Coed N.Wales

Started 1983

100 ft. diametre ring of blue wild bulb flowers, appears briefly each May.

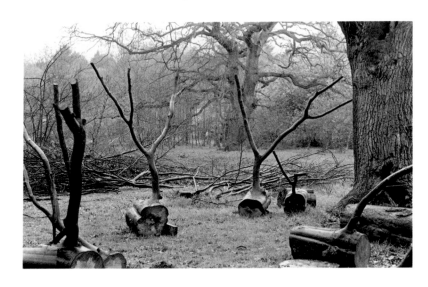

VIII

Lump and Length

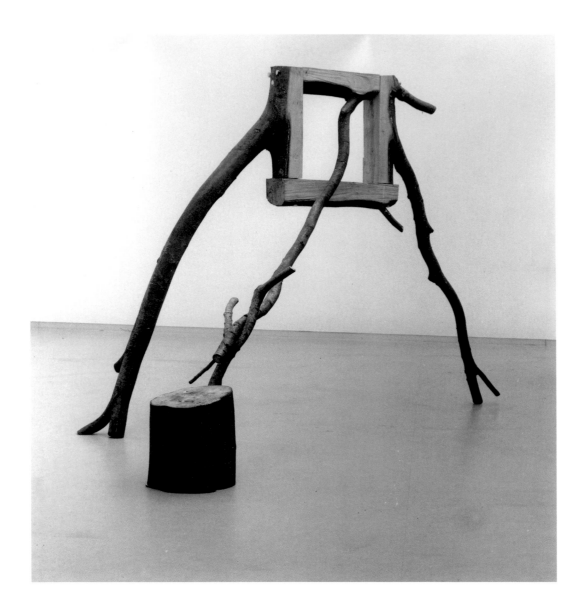

Standing Frame, beech, Otterlo, The Netherlands 1982

42

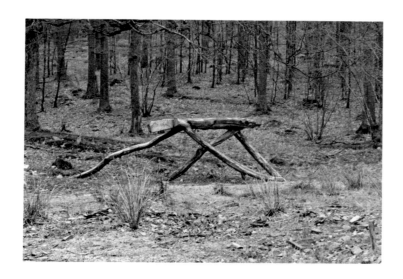

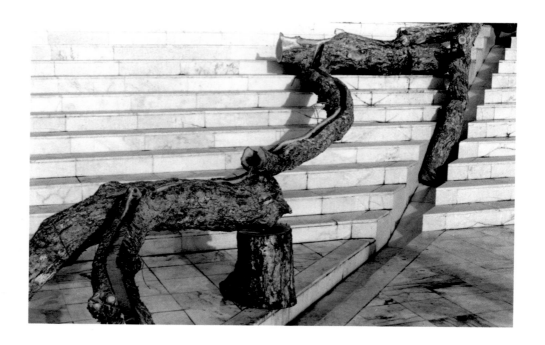

Running Table, oak, Cumbria, England 1978
Waterway, mizunara, Tochigi, Japan 1982

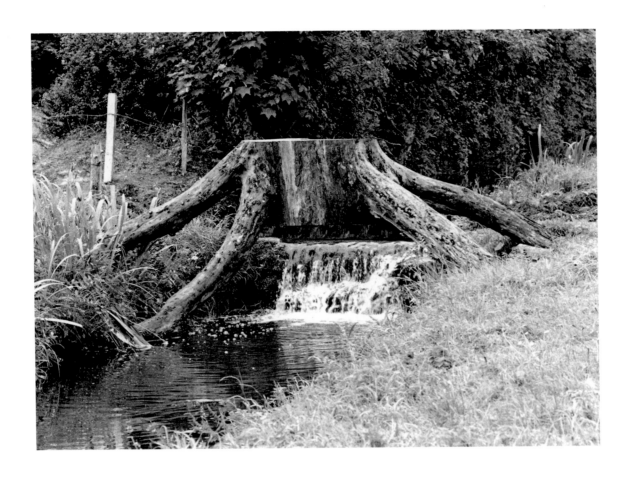

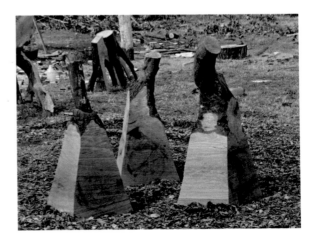

Bridge, elm, Tipperary, Ireland 1984
Pyramids with Handles, red oak, St. Louis, Missouri 1983

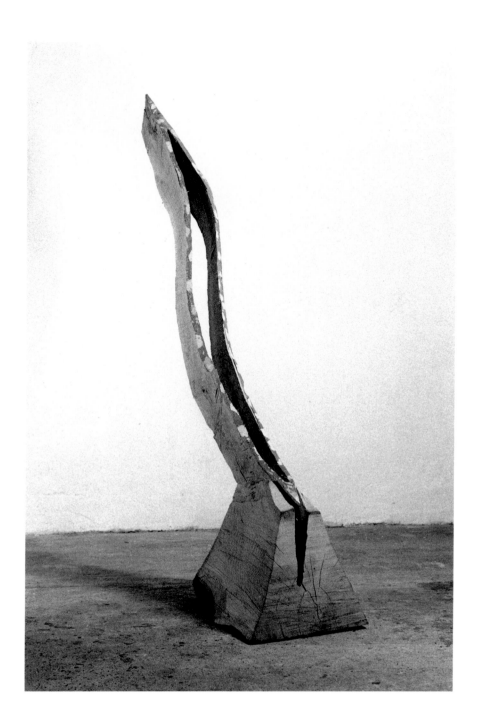

Falling Boat, oak, Forest of Dean, England 1986

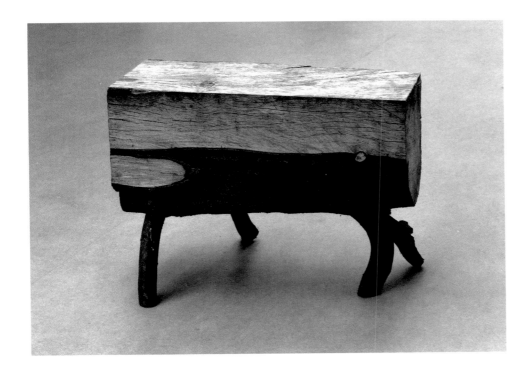

A Useful Pig, beech, Otterlo, The Netherlands 1982

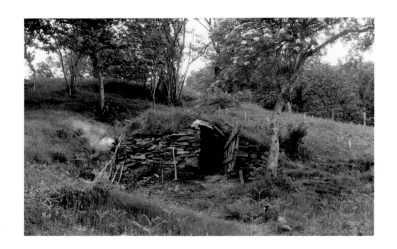

IX

Stove and Hearth

heat
earth
heart
hearth
art

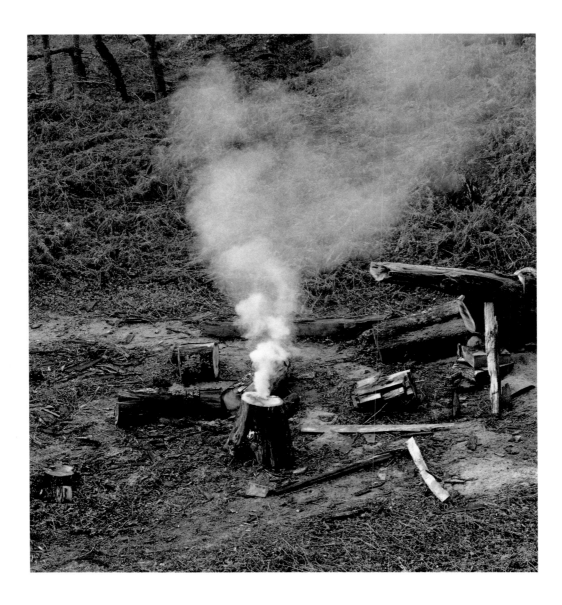

Wood Stove, oak, N. Wales 1978

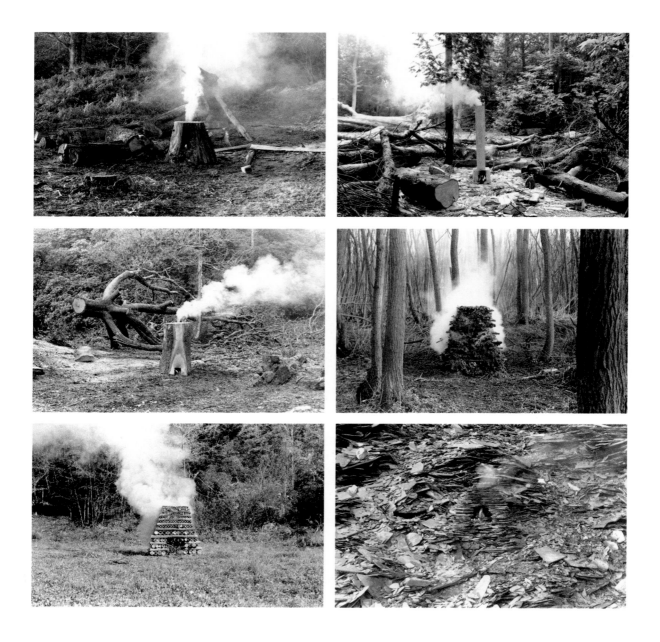

Wood Stove, N. Wales 1979 *Lime Stove,* England 1983
Wood Stove, N. Wales 1980 *Sticks and Clay Stove,* Biesbos, The Netherlands 1981
Bamboo Stove, Japan 1984 *Slate Stove,* N. Wales 1981

49

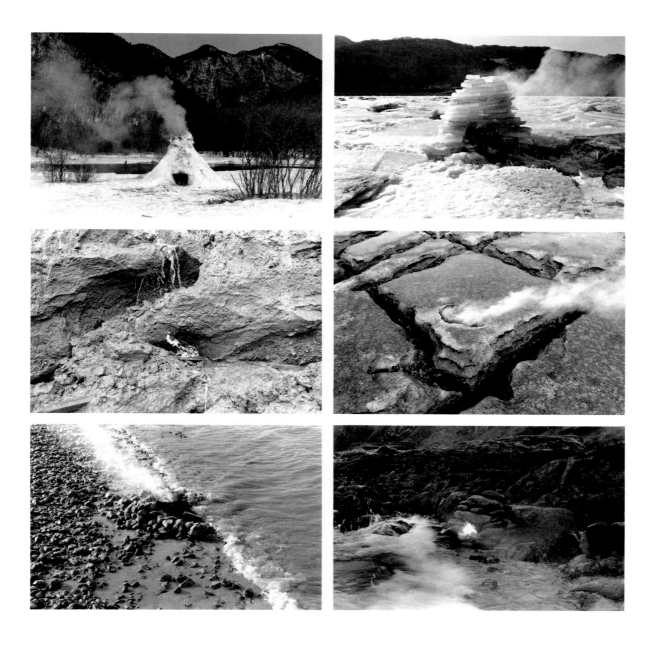

Snow Stove, Japan 1982

Ice Stove, N. Wales 1986

Earth, Air, Fire, Water, N. Wales 1982

Burren Hearth, Ireland 1982

Sea Hearth, Southampton, England 1981

Sea Hearth, Scotland 1981

WOOD PRIMER

X

Inside-Outside

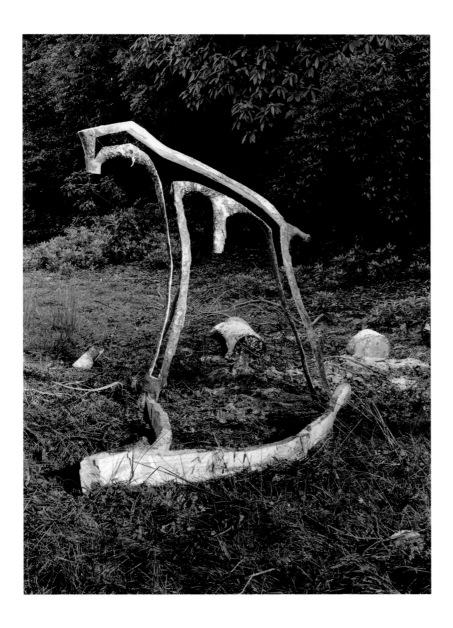

Mount and Foal, sycamore, N. Wales 1982

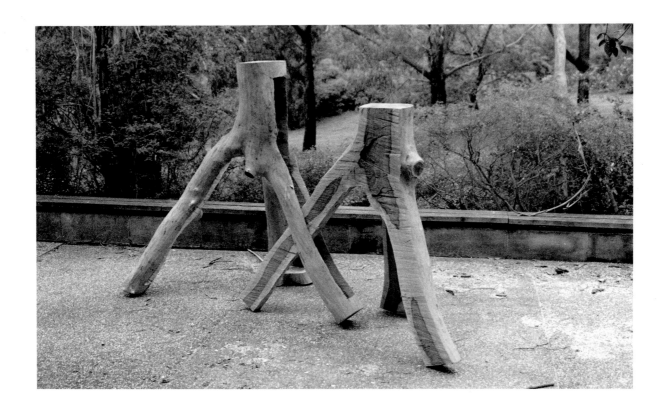

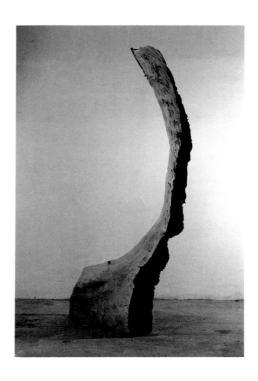

Inside-Outside, elm, Australia 1985
Upper Cut, lime, N. Wales 1984

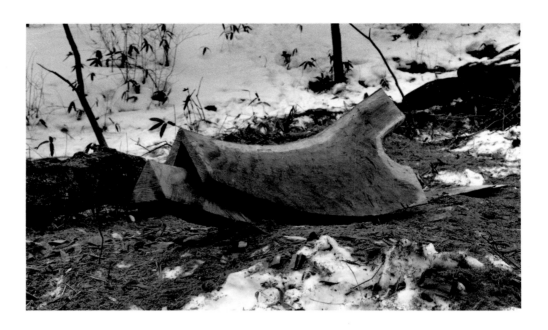

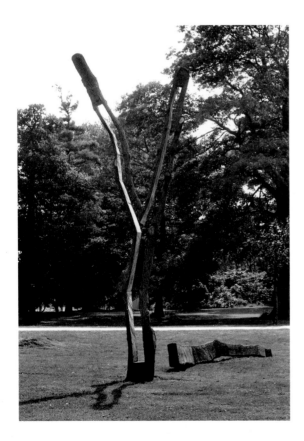

Wooden Fish, mizunara, Kotoku, Japan 1982
Big Y, elm, Yorkshire, England 1982

XI

Charring

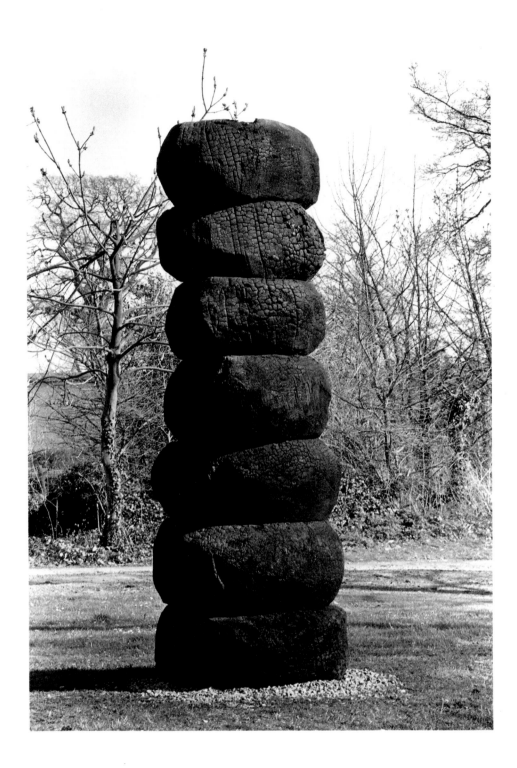

Seven Charred Rings, oak, S. Wales 1986

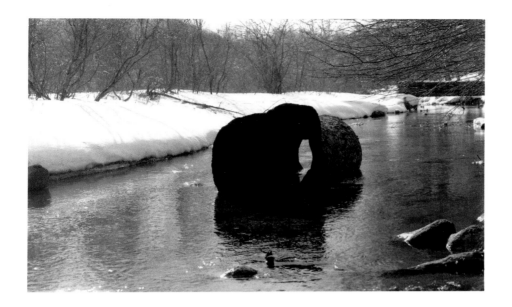

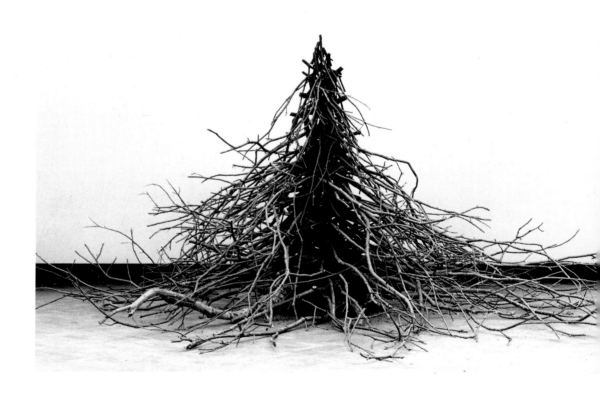

River Tunnel, mizunara, Kotoku, Japan 1982
Black Column in the Sticks, chestnut, N. Wales 1983

57

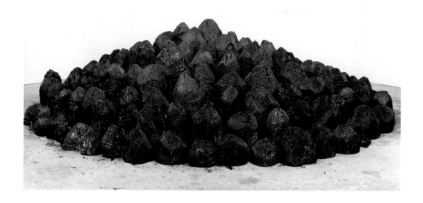

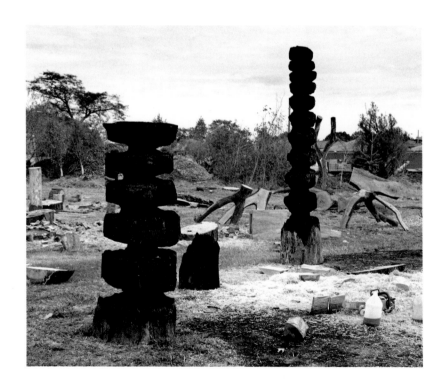

Black Dome, chestunut, N. Wales 1986
Black Columns, sycamore, St. Louis, Missouri 1983

WOOD PRIMER

XII

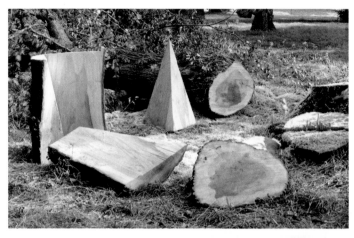

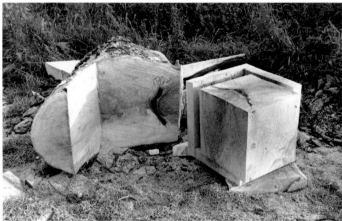

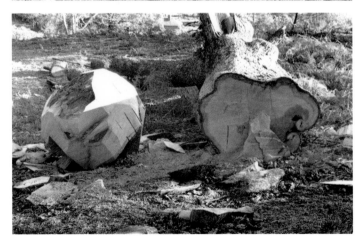

Pyramid and Mould, elm, Yorkshire, England 1981
Cube Cubed, elm, England 1979
Wooden Boulder, oak, N. Wales, 1978

60

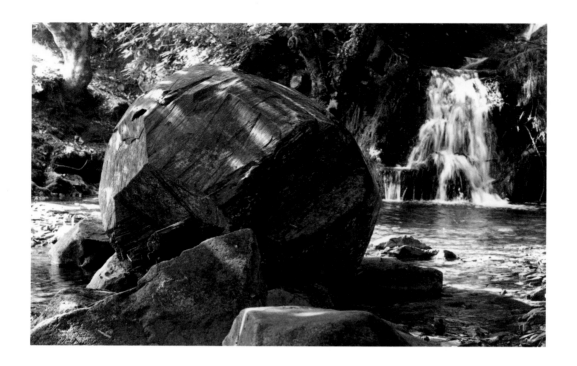

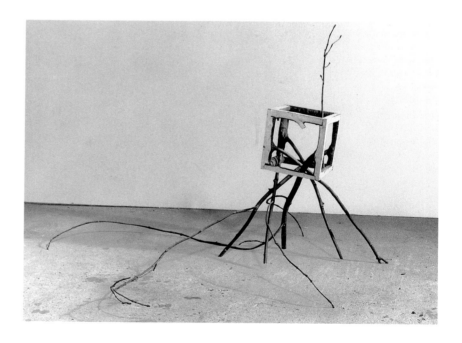

Wooden Boulder, oak, N. Wales 1980
Ash Stick Cube, N. Wales 1979

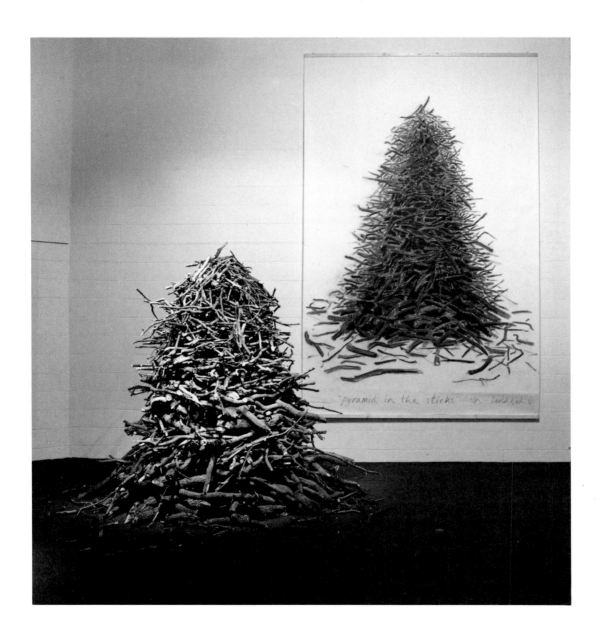

Pyramid in the Sticks, elm, Ireland 1983

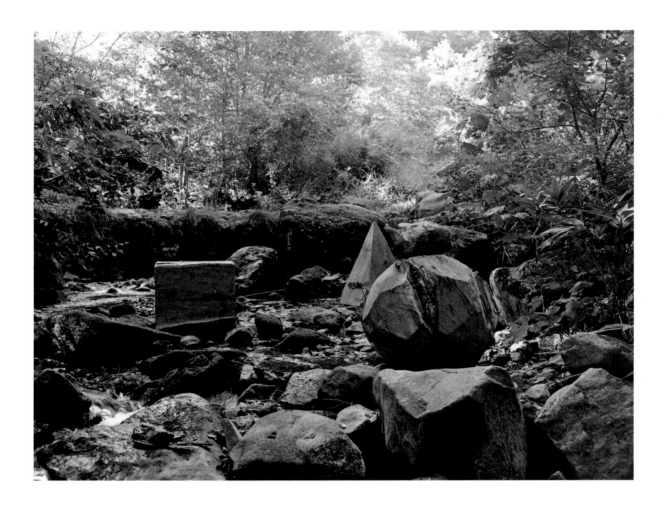

From Nature to Nature: into Water, Hatasaka, Japan 1984

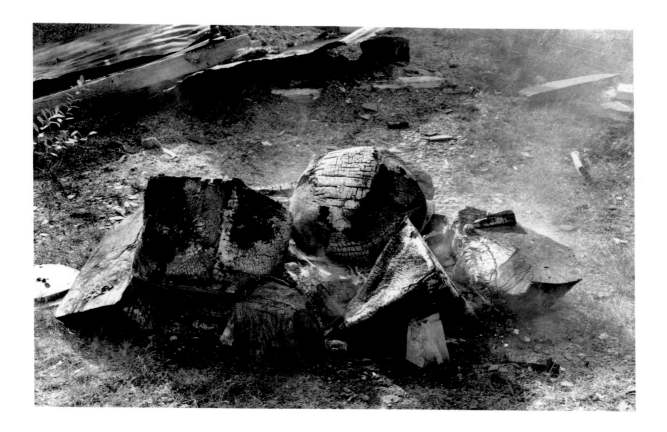

From Nature to Nature: into Fire, N. Wales 1986

Wood Quarry

WOOD QUARRIES 1978 – 1986

Bronturnor oak, N. Wales 1978-80

Tan-y-bwlch oak, N. Wales 1979-80

Pyramids and Catapults, elm, Yorkshire, England 1981

20 Days with a Mizunara, Kotoku, Japan 1982

Wood Quarry — Otterlo, beech, Kröller Müller Museum, The Netherlands 1981-2

Phoenix Elm, Dublin, Ireland 1983

Removals and Conversions, lime, Berkshire, England 1983

Red Oak, St. Louis, Missouri 1983

Roth's Elm, Tipperary, Ireland 1984-5

Hatasaka oak, Miyagi, Japan 1984

Kino Inochi Kino Katachi, Kotoku, Japan 1984

Mixed Wood, Karasygama, Japan 1985

Elm, Wattle, Gum, Melbourne, Australia 1985

Maenen Ash, N. Wales 1986

200 Years and 10 Days, oak, S. Wales 1986

Forest of Dean oak, Forest of Dean, England 1986

65

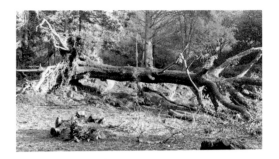

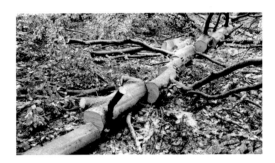

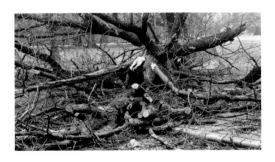

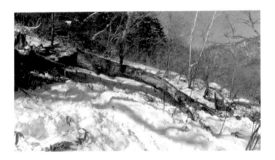

Oak, Tan-y-Bwlch, N. Wales 1979-80
Wood Quarry, beech, Kröller Müller Museum, The Netherlands 1981-82
20 Days with a Mizunara, Kotoku, Japan 1982
Redwood, Forest Park, St. Louis, Missouri 1983

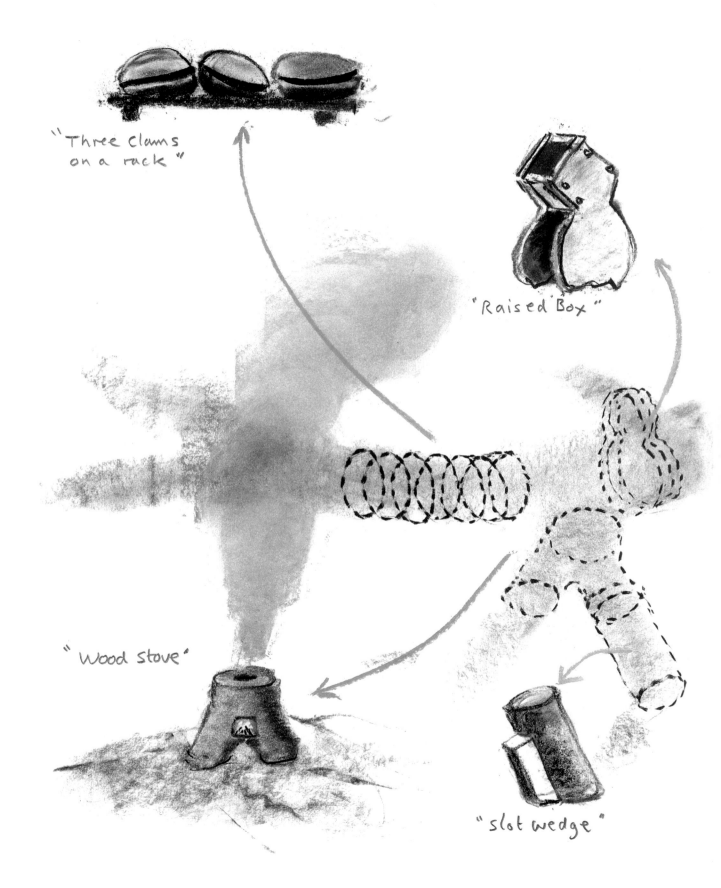

"Three clams on a rack"

"Raised Box"

"Wood stove"

"slot wedge"

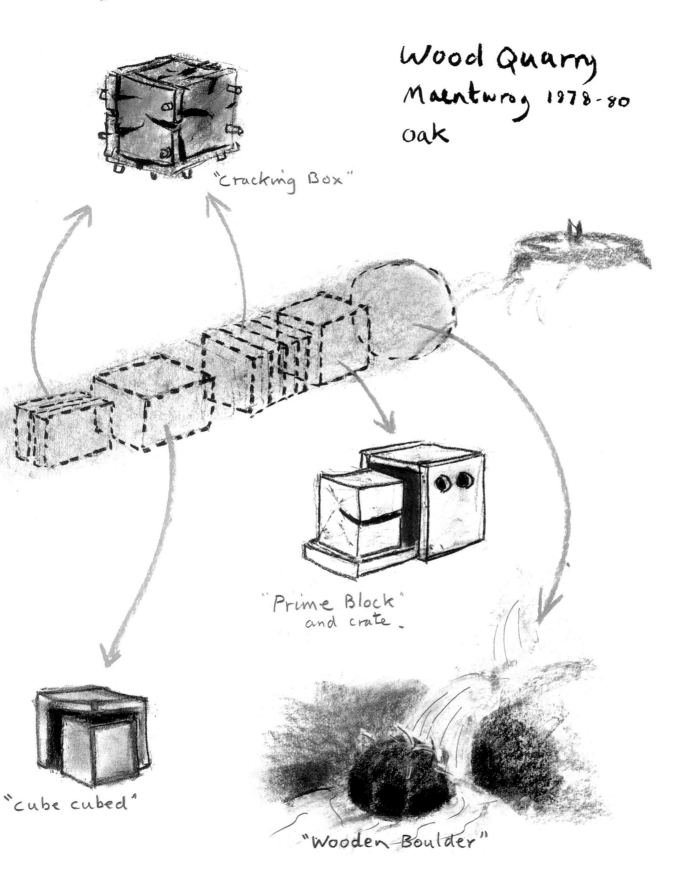

Wood Quarry
Maentwrog 1978-80
Oak

"Cracking Box"

"Prime Block"
and crate.

"cube cubed"

"Wooden Boulder"

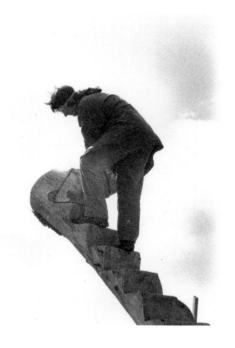

This book was conceived by David Nash.
Design coordination and production by
Jon Goodchild and Richard Wilson, Triad,
San Rafael, California.